THE FLIGHT INTO EGYPT

Introduction and captions by COLTA FELLER IVES

Curator-in-Charge of Prints

The Metropolitan Museum of Art

PICTURESQUE IDEAS ON THE

FLIGHT INTO EGYPT

ETCHED BY GIOVANNI DOMENICO TIEPOLO

GEORGE BRAZILLER NEW YORK

GIOVANNI DOMENICO TIEPOLO'S set of twenty-seven etchings entitled *Picturesque Ideas on the Flight into Egypt* is perhaps the most enchanting of his printmaking accomplishments. Within the history of printed scenes of Christ's life, which began in the fifteenth century, this series is probably unique in format; there is no other depiction known of the Flight into Egypt in such an extended sequence. Beyond this novel aspect, the set reveals the inspiration of Tiepolo's native Venice—her sunny skies and sparkling lagoons, her passion for theatrical spectacles, her artistic heritage of pageant masters. The joyous effects of light, space, and air in these prints reflect the achievement of the eighteenth-century Venetian etchers whose characteristic broken lines captured their city's shimmering atmosphere.

Born in 1727, the son of Giovanni Battista Tiepolo, the period's greatest fresco painter, Domenico was a precocious artist. At the age of twenty he was commissioned to paint the stations of the cross for the Church of St. Paul in Venice; he published these fourteen large compositions as a series of etchings in 1749. As immediate forerunners of the present set, the prints of the *Via Crucis* demonstrate the young artist's flair for the episodic and the picturesque. They are the first of several religious subjects for which Domenico devised extended series of designs.

Domenico was twenty-three when he began to etch the plates for his Flight into Egypt. It has been said that he designed them in order to defend his artistic reputation: to prove

INTRODUCTION ❧

that he could invent twenty-four pictures on the same subject without repeating himself. According to Tiepolo's dating of some of his plates, the work spanned a period of at least two years. Plate 13 bears the earliest date, 1750. This was the year in which Domenico accompanied his father to Würzburg, where the elder artist had been commissioned to decorate the rococo Residenz of Carl Philipp von Greiffenklau, the prince-bishop. At Würzburg Domenico for the first time worked with his father on a decorative cycle of considerable importance, collaborating in the creation of allegorical works that combined pagan deities with members of the German nobility and their colorful retinues. As chief assistant in the painting of the frescoes, Domenico must have worked on his plates as time allowed; however, he finished them before he left Germany in 1753, and he dedicated the set to his father's patron, the prince-bishop.

The story of the Flight has always appealed as a dramatic event in Christ's infancy; it is surprising, therefore, to find it treated so briefly in the Bible. Only the evangelist Matthew writes of what took place when Herod attempted to protect his power against that of the future King of the Jews:

> Behold, the angel of the Lord appeareth to Joseph in a dream, saying, Arise, and take the young child and his mother, and flee into Egypt, and be thou there until I bring thee word: For Herod will seek the young child to destroy him.

When he arose, he took the young child and his mother by night, and departed into Egypt:

And was there until the death of Herod: that it might be fulfilled which was spoken of the Lord by the prophet, saying, Out of Egypt have I called my son.

Matthew II: 13–15

Egypt, the temporary refuge of many biblical personages, seems to have been the Holy Family's place of exile for two to seven years. Authorities differ not only on the duration of the stay but on the locale, but this is generally held to have been Matarea, near Cairo.

Although the Bible tells us nothing of the events of the Holy Family's journey, popular imagination quickly devised legends surrounding the Christ child's escape. Writers of the Apocrypha began to embellish the story in the second century. The visual arts were slower in their use of the story. Not until the twelfth century did the miraculous tales of the Apocrypha find their way into painting and sculpture. By the early sixteenth century the reformed Church began to challenge the old formulas for representing sacred events, and Ignatius Loyola's book of *Spiritual Exercises* (1548) invited each Christian to imagine the evangelical scenes in his own way. As a result, artists' interpretations of the Flight became more personal. Although Domenico incorporated into his version three popular themes, the legends of the Palm Tree, the Fountain, and the Falling Idol, he otherwise avoided

literary sources, preferring to draw inspiration from events of everyday life and his own brisk imagination. To a great extent he relied upon the visual interpretations of older artists. About 1745, before he began the set, Domenico etched two of his father's pictures of the subject. It has always been difficult to separate the younger Tiepolo's work from his father's, particularly during the Würzburg period, and Giovanni Battista Tiepolo no doubt played a significant role in the conception of his son's prints. Beyond the guidance of his father, Domenico seems to have been influenced by the seventeenth-century printmakers whose etchings he collected. From Rembrandt, Stefano della Bella, and especially from Benedetto Castiglione and Sebastian Bourdon, he borrowed spatial and lighting effects as well as specific figures and scenery.

Because many of Domenico's works, particularly his prints, were inspired by his father's designs, the younger Tiepolo has often been denied proper credit for his own achievements. The Flight into Egypt, however, demonstrates the distinctly personal and tender character of Domenico's art. His fondness for simple genre scenes is revealed in many intimate details: a baby raptly watching vapor rise from a bowl, a husband and wife engaged in quiet conversation, a donkey contentedly chewing grass.

Most of the plates, save for those at the beginning, do not suggest a definite sequence. Some are grouped thematically, such as those describing the Family's passage of a river. Changes in the appearance and character of the principal figures, likewise variations in the

emotional tone, indicate that there were lapses of time between some of the plates. In the end the artist numbered them in the order that seemed most appropriate to him.

As always in Domenico's work, one finds little attempt at composition in depth. Here, the activity of each plate occurs within a narrow space close to the picture surface. The "ideas" are only loosely linked; each plate presents a new action, a new pictorial pattern, a new relationship of figure to figure.

Because Tiepolo lived at a time when, among Italian artists, an original composition was more highly prized than one that was iconographically correct, he constantly had to delve into his own experience and imagination for fresh material. To furnish his art, he gathered and combined elements of both reality and fantasy—reality of the rustic genre-type in which he delighted, fantasy of the enigmatic sort that breezed through his father's etchings. The pageant of this Flight is delicately balanced, endearing yet respectful, not at all pompous, and only barely pious. The set clearly owes more to idyllic poetry than it does to religious dogma. Tiepolo meant it to please first of all, and perhaps then to teach.

All but two of the prints reproduced here in facsimile are from the collection of the Metropolitan Museum's Department of Prints and Photographs (Purchase, Bequest of Florance Waterbury, 1970.692.1–25). The dedication plate and the title plate, missing from the Museum's set, are reproduced from the prints in the collection of the Yale University Art Gallery.

THE FLIGHT INTO EGYPT ❧

A
Sua Altessa Reverendissima
Monsignor
CARLO FILIPPO
Prencipe del Sacro Romano Impero
Vescovo d'Herbipoli
Duca di Franconia
Orientale
&c &c

With fanfare, the allegorical figure Fame escorts a symbolic representation of Prince-Bishop Carl Philipp von Greiffenklau. Two putti carry the bishop's miter and stole, while an angel bears the Greiffenklau coat of arms above the fortress of Marienberg, the palace of Würzburg prince-bishops from 1250 until 1750, when the new Residenz was completed and decorated by the Tiepolos.

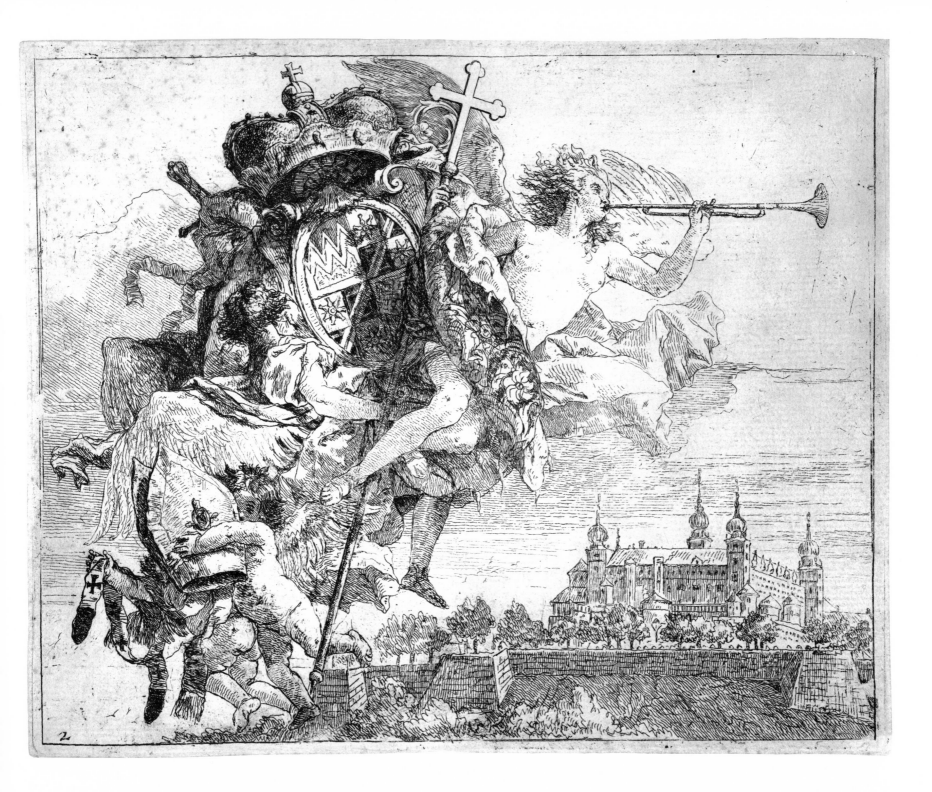

2

Picturesque Ideas on the Flight into Egypt
of Jesus, Mary, and Joseph,
a work invented and etched by me,
Giovanni Domenico Tiepolo,
in the court of the aforesaid,
his most reverend highness . . .
in the year 1753

Idée Pittoresche

Sopra

La Fugga in Egitto

di

GIESU, MARIA e GIOSEPPE

Opera

inventata, ed incisa

da me

Gio: Domenico Tiepolo

in

Corte di detta

Sua Altessa Reverendissima &. &.

Anno 1753.

PLATE 4

Framed by an open window and attended by an angel signaling revelation, Joseph announces that the family must "arise . . . and flee." Ignoring the warning, the Christ child continues to gaze at the vapor rising from a bowl, which symbolizes the fleeting nature of his earthly life. He grasps a ring, a circle, the sign of eternity.

Tiepolo fills this room with fresh air and sunshine. It is the only indoor scene in the set.

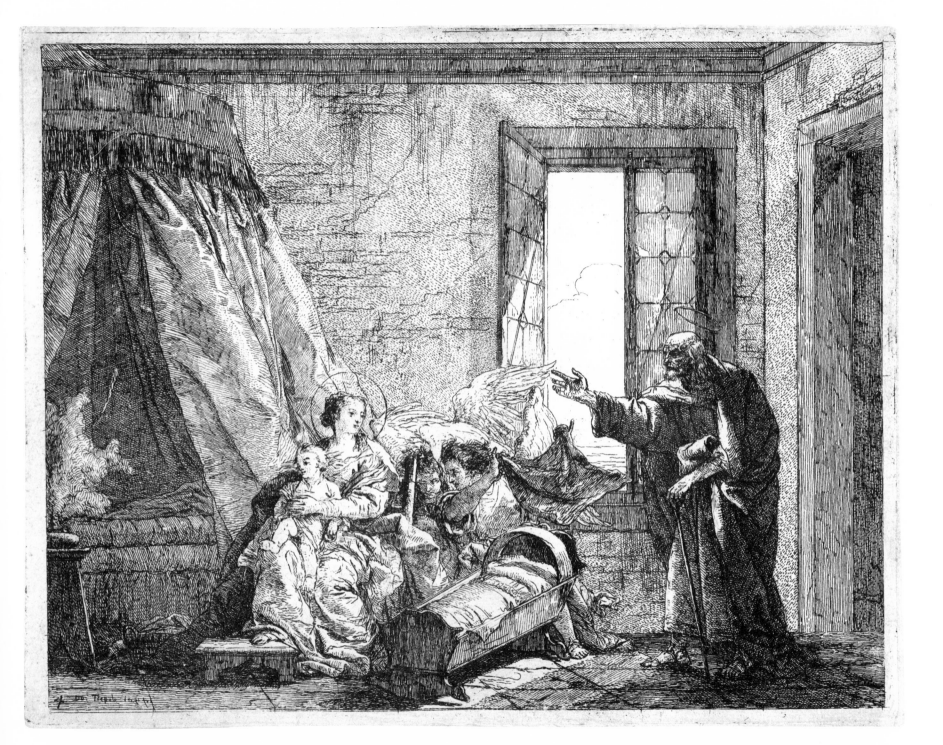

PLATE 5

Saint Luke tells the story of Simeon, a "just and devout" man who had been promised "that he should not see death, before he had seen the Lord's Christ." Led by the Divine Spirit to Jesus, "took he him up in his arms, and blessed God, and said, Lord, now lettest thou thy servant depart in peace, according to thy word: for mine eyes have seen thy salvation."

The meeting of Simeon and the infant Christ is usually depicted in scenes of the Presentation in the Temple. Tiepolo preferred a rustic setting in which to portray Mary's amazement at Simeon's praise, "Behold, this child is set for the fall and rising again of many in Israel," and her distress at his prediction that "Yea, a sword shall pierce through thy own soul also." Simeon's prophecy of the Crucifixion is echoed in the crossed planks of the door.

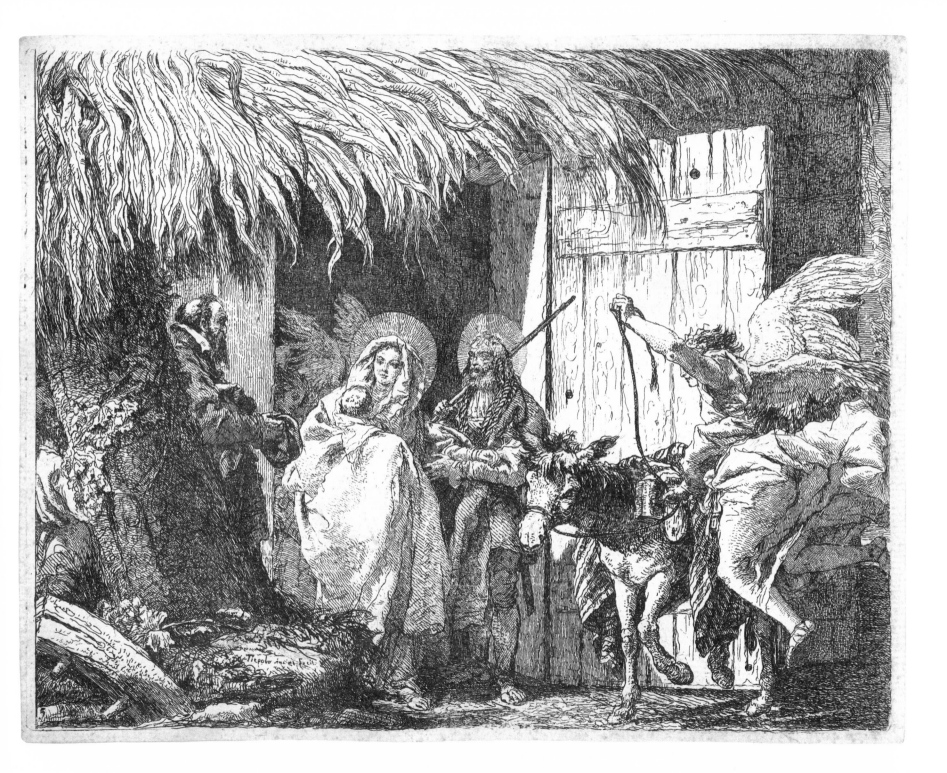

PLATE 6

Anna the Prophetess, described by Luke and sometimes pictured with Simeon, "gave thanks likewise unto the Lord, and spake of him to all them that looked for redemption in Jerusalem." Because she did not hold the child, she is regarded as a symbol of the Synagogue, which prophesied the Messiah but did not embrace him when he came.

Tiepolo's old merchant-woman derives from the egg-seller in Titian's painting *The Presentation of the Virgin in the Temple*. Possibly her sibylline presence in Tiepolo's etching was prompted by the Italian ballad, "Of Our Lady, When She Fled Into Egypt," which tells of Mary's encounter with a *zingarella*, or gypsy, who foretold the infant's destiny.

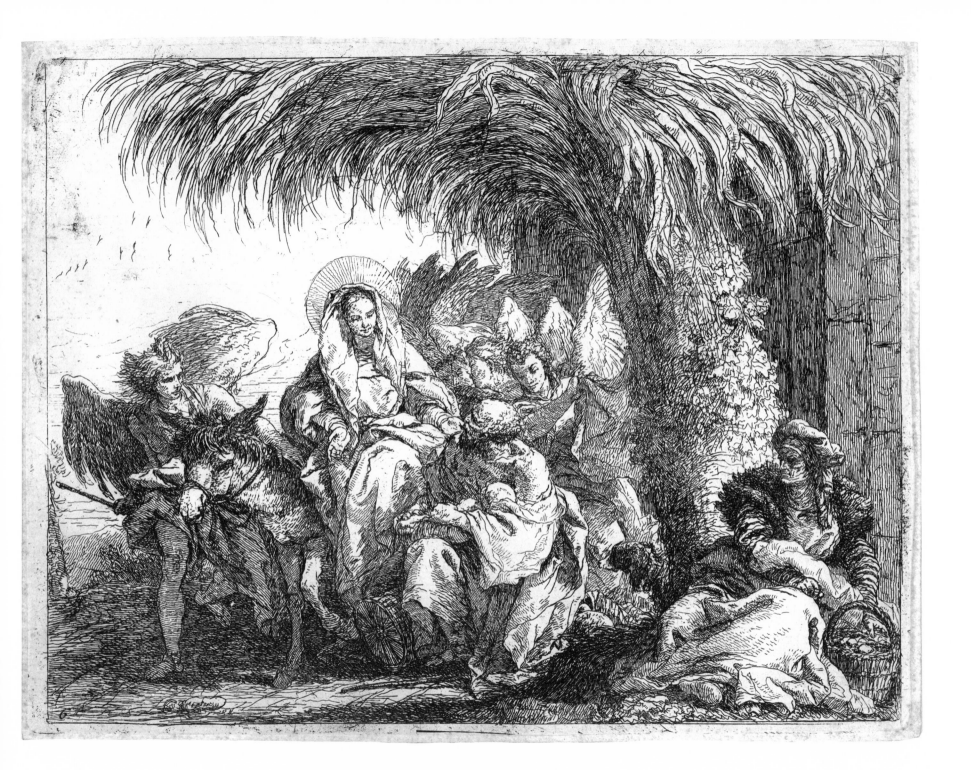

PLATE 7

The Holy Family departs from Bethlehem watched by a crowd of turbaned orientals and peasants. Venetian painters, from Carpaccio and Veronese on, peopled their sacred scenes with similar picturesque types.

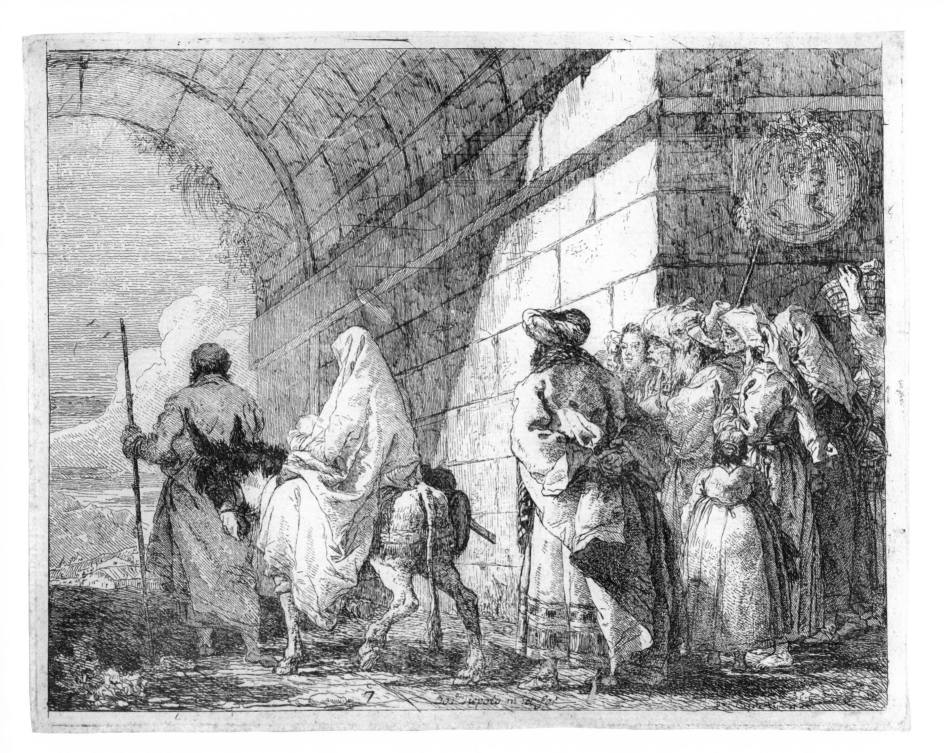

7 Dom.° Tiepolo in f.

PLATE 8

For centuries the Flight had an immutable character in art: the Virgin cradling the infant in her arms, seated on an ass, while Joseph walks before. There might be a walled town in the background while a palm tree conveys the desert locale. Observing the traditional formula, Tiepolo adds witnesses to the scene: an apprehensive shepherd, and God the Father (his image borrowed from the ceiling of the Sistine Chapel).

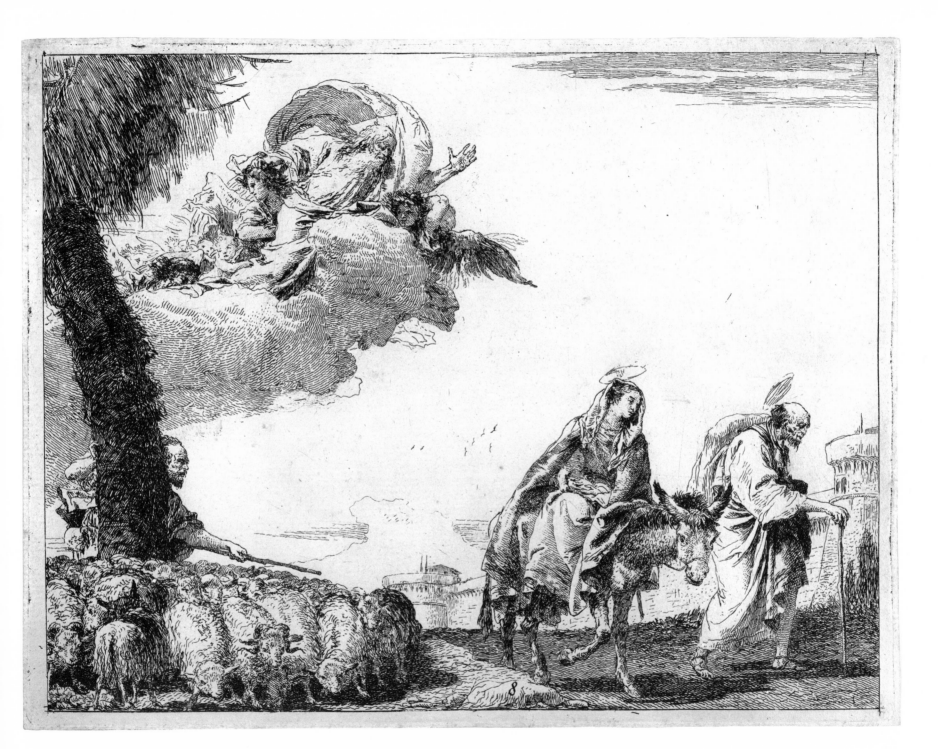

PLATE 9

Tiepolo establishes the family's unity with a triangular composition dominated by Mary, the personification of devotion and grace. The family portrait is romantic and idealized, yet sincere.

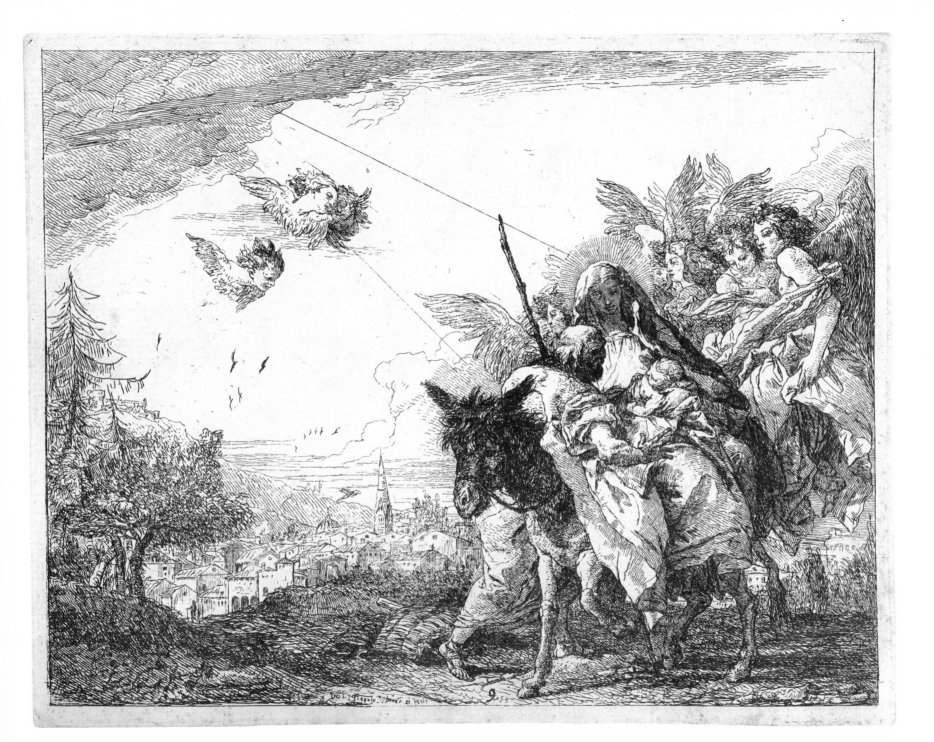

Dom.o Tiepolo inven. et fecit 9.

Tiepolo liked to picture his subjects from behind, often placing them in a foreground filled in the manner of a stage design. Here he employs a snail's-eye perspective to dramatize the persevering travelers.

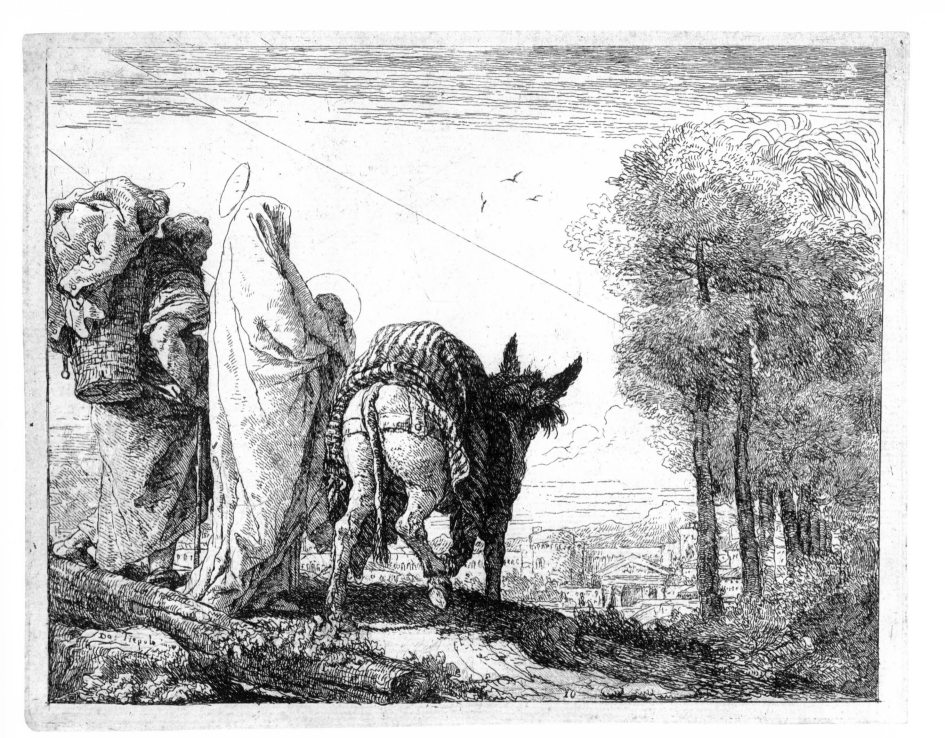

PLATE 11

Most seventeenth-century Italian painters believed that nothing mundane should distract from the pious contemplation of Christian scenes, and for them, sacred personages paraded only on clouds and dwelled in mists. Tiepolo, an artist of the eighteenth century, departed from that tradition. He imagined a Holy Family that traveled on earth, and supplied the appropriate scenery.

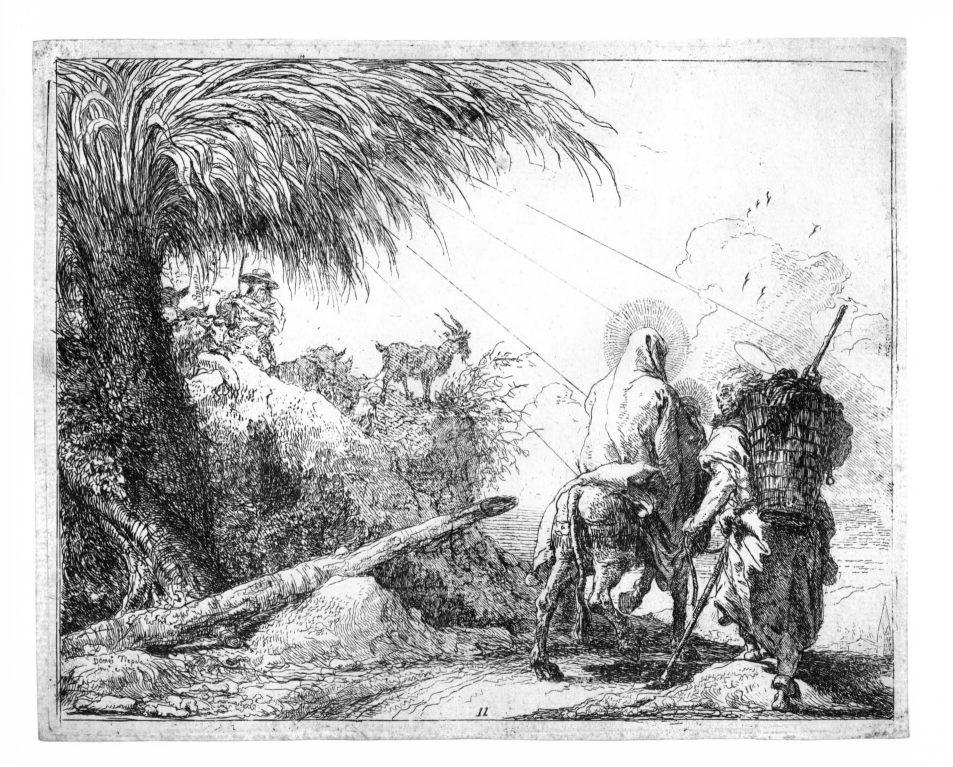

Dōme͞s Tiepolo

11

PLATE 12

During the Middle Ages Joseph's role in religious representation was inconsequential. (He was considered a weak, sometimes senile, old man.) However, beginning in the seventeenth century, the foster father's image acquired vigor and nobility comparable to that of an Old Testament prophet. Here, the vigilant guardian, he carries the infant Jesus before spectators and classical ruins, the latter signifying the crumbling of pagan beliefs in the presence of Christianity.

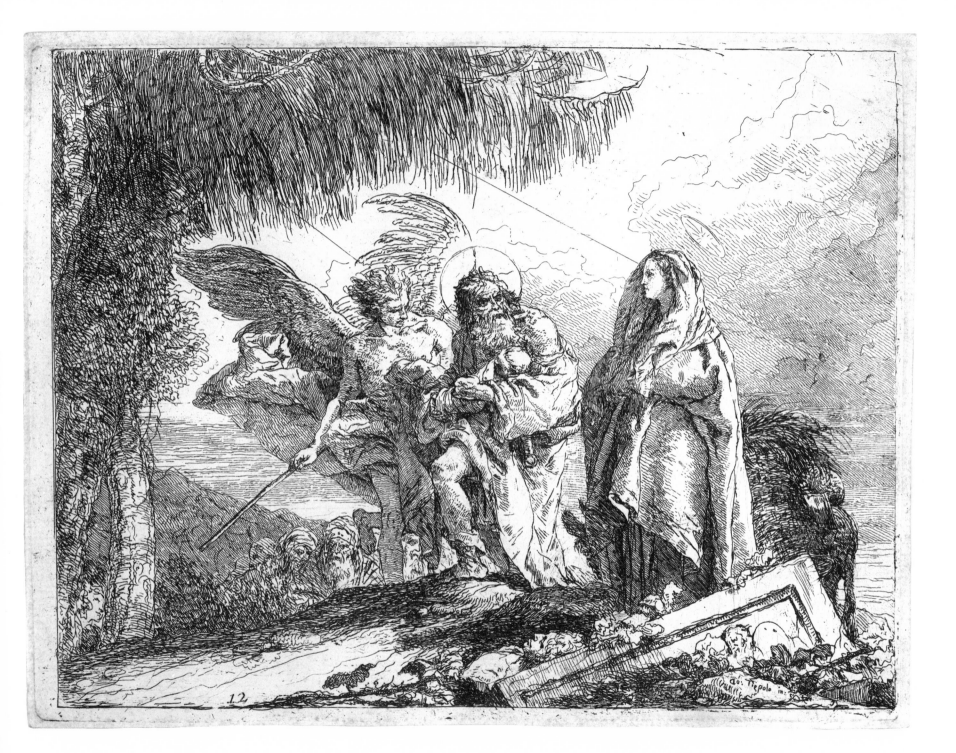

PLATE 13

The Holy Family rests, an appropriate occasion for the adoration of Christ by angels. Called the Repose, this moment provides one of the most attractive subjects in Christian art. The romantic and pastoral character of the scene made it popular with landscape painters, particularly the Venetians.

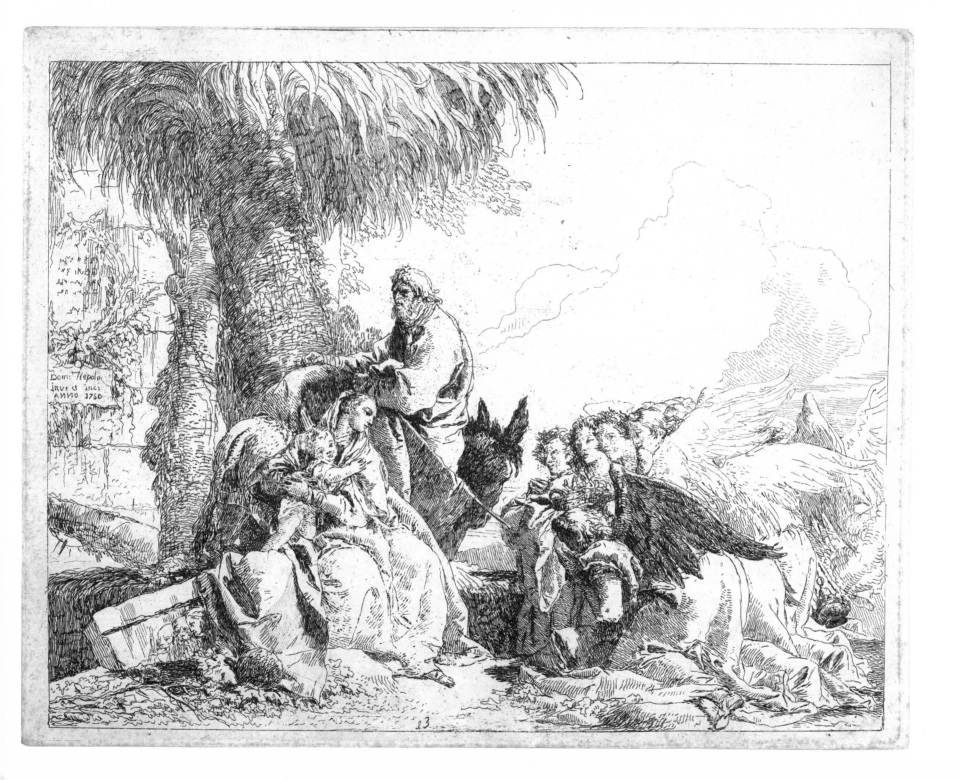

13

PLATE 14

A boatman ferrying the Holy Family across a body of water emerged from the Counter Reformation as a significant contribution to the subject of the Flight. Although the incident is not mentioned in either canonical or apocryphal scripture, it offered artists an opportunity for scenic variety.

In this and the following four plates Tiepolo displays his Venetian love of sparkling waters and vast skies. Adopting the etching technique of Canaletto, he creates a vibrant atmosphere with broken parallel lines. Within this mosaic of hatches, Mary assumes the noble air of a Byzantine icon. Her stately manner contrasts with that of the energetic, wind-tossed angel.

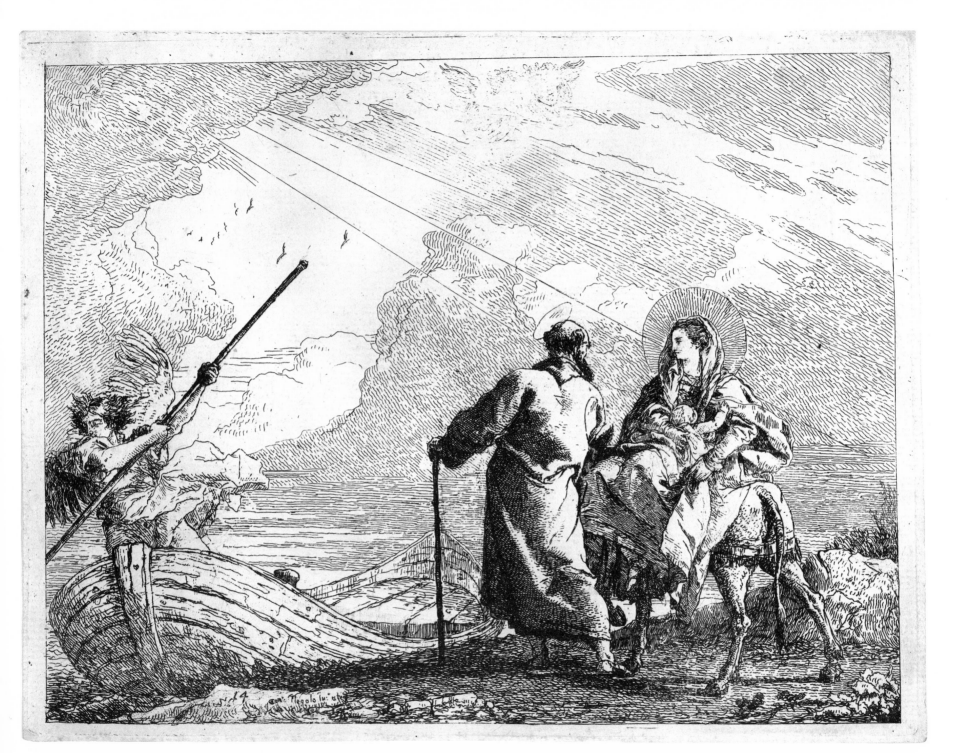

PLATE 15

Other artists who portrayed the ferry and boatman were Carracci, Poussin, Castiglione, and Testa, whose designs included a vision of the cross as a reminder of Christ's Crucifixion. The passage of a river and the theme of death are also linked in the classical interpretation of the ferryman as Charon preparing to transport the child across the river Styx.

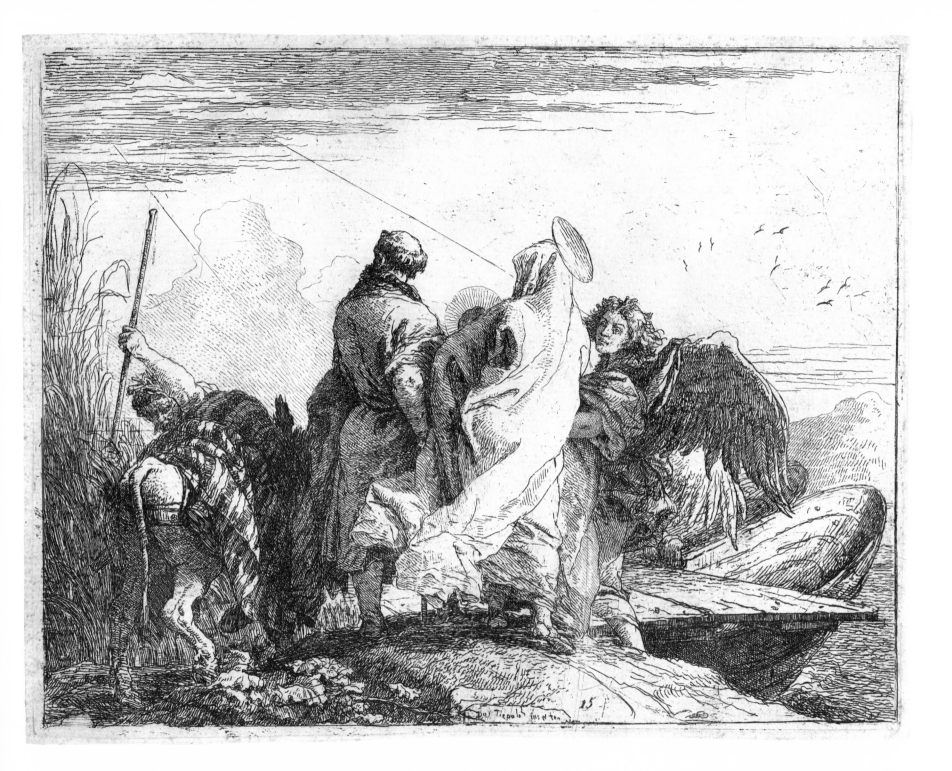

PLATE 16

Tiepolo imparts a pleasant air of adventure to this scene; one would think the passengers were embarking on a holiday rather than escaping Herod's massacre. The similarity of this episode to the rescue from the Nile of the infant Moses (Christ's forerunner in the Old Testament) suggests that the water is the instrument of salvation.

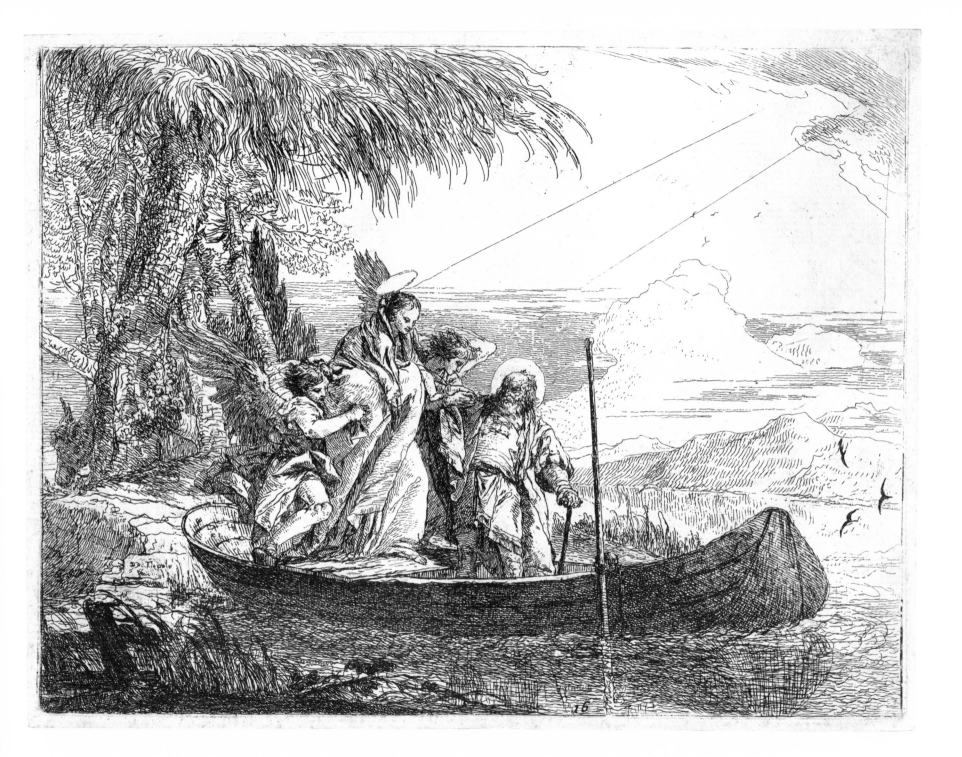

PLATE 17

The family's boat is propelled gondola-style by a Venetian angel whose enthusiasm and determination recall St. Michael slaying the dragon. Tiepolo's swans, ruffling their feathers at the boat's approach, introduce the sort of lyricism desired by rococo tastes.

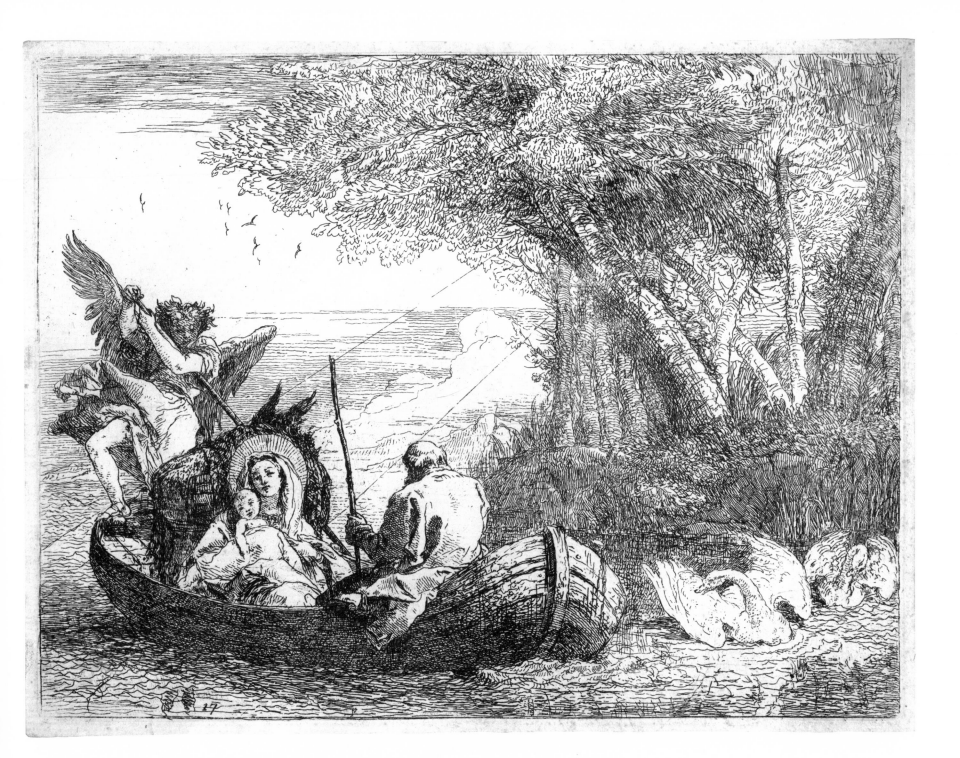

PLATE 18

The ass is led ashore in an embrace that acknowledges his vital role in the Flight. This humblest of creatures bore Mary from Nazareth to Bethlehem and witnessed the Nativity. Folklore tells us that Christ, in gratitude for his warm breath in the cold manger, marked the ass's back with a cross of dark hair. By that mark his descendant might be chosen to carry Christ into Jerusalem on Palm Sunday. In French legend the cross on the ass's shoulders is regarded as a reward for service during the Flight into Egypt.

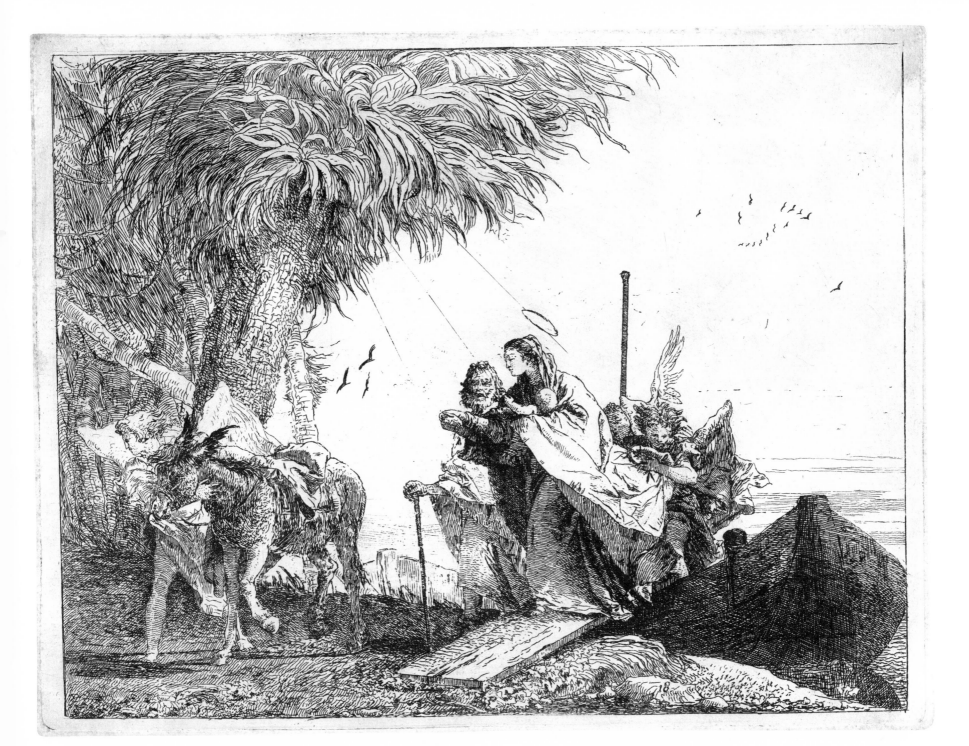

PLATE 19

The Gospel of Pseudo-Matthew relates how Mary on the third day of the journey was fatigued and stopped to rest beneath a palm tree, whereupon her son commanded the tree to bow and shade and refresh her. Beginning in the fifteenth century this palm became traditional in representations of the Flight. The fronds are sometimes bent by angels who gather the fruit to nourish the travelers.

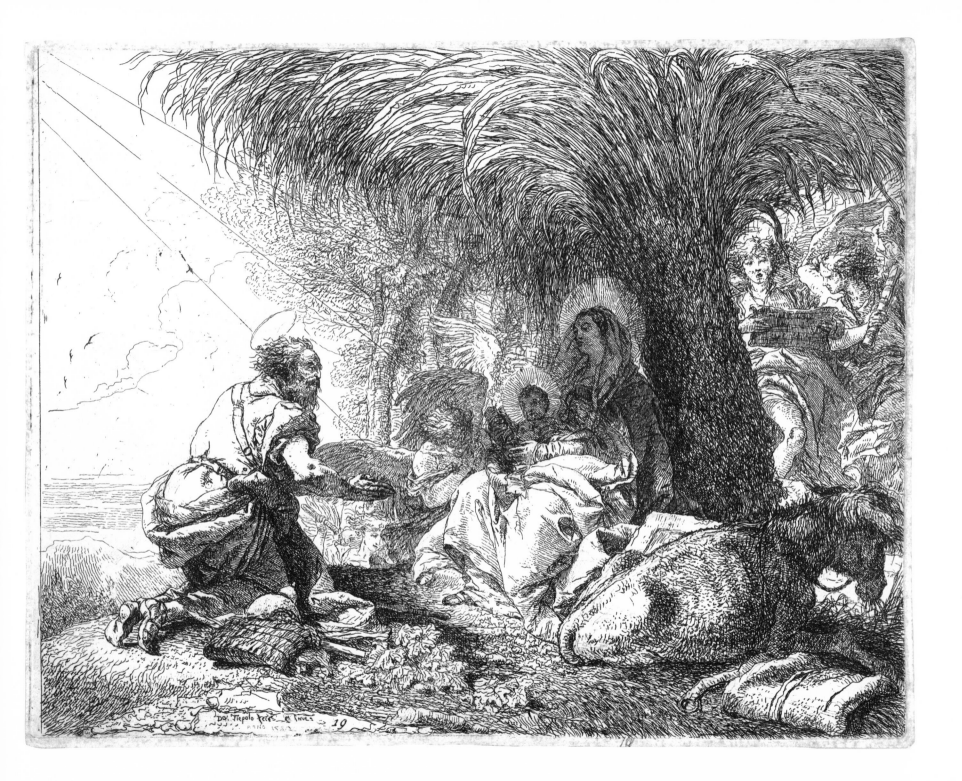

Do. Tiepolo Fece C Inve 19

PLATE 20

It is supposed that the Holy Family traveled from Bethlehem across the hills of Judea, then took the road to Joppa, and made their way from there along the coast. Tiepolo's empty sky and barren landscape express the solitude and hardship of the long journey.

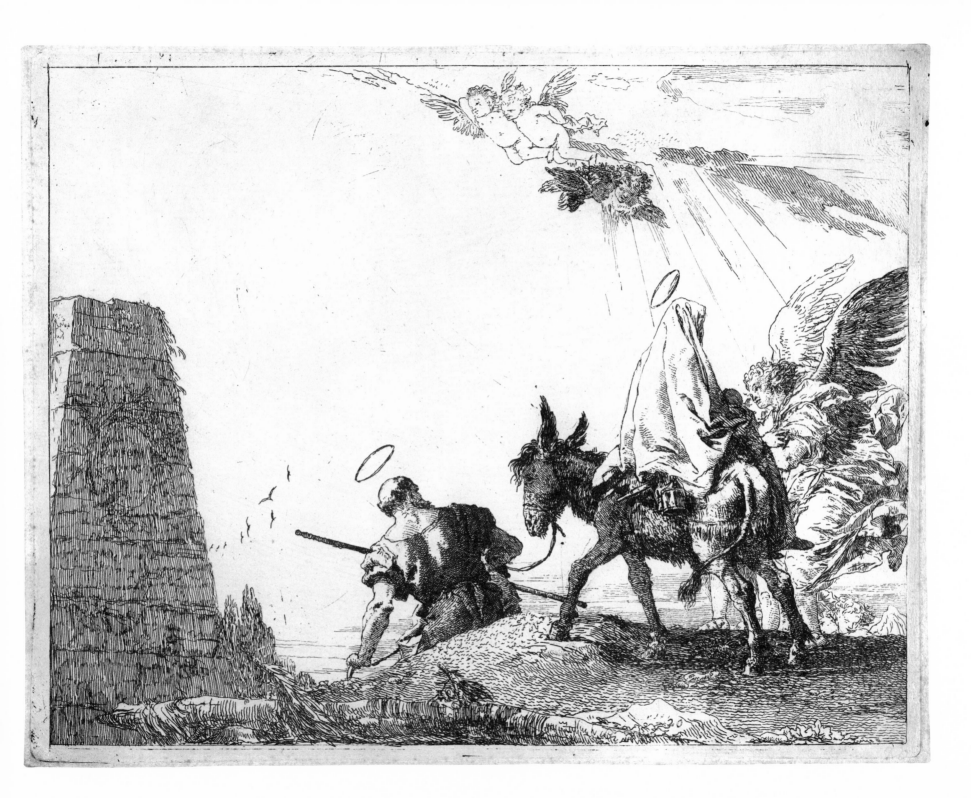

PLATE 21

His fondness for lively detail depicted in broad daylight led Tiepolo to create sunny and lighthearted surroundings through which the Holy Family might happily travel. Descending a hill, Mary and her baby are helped around a bend by an angel keeping pace with the energetic Joseph. Straying sheep obediently make way for the child who will someday be called Shepherd.

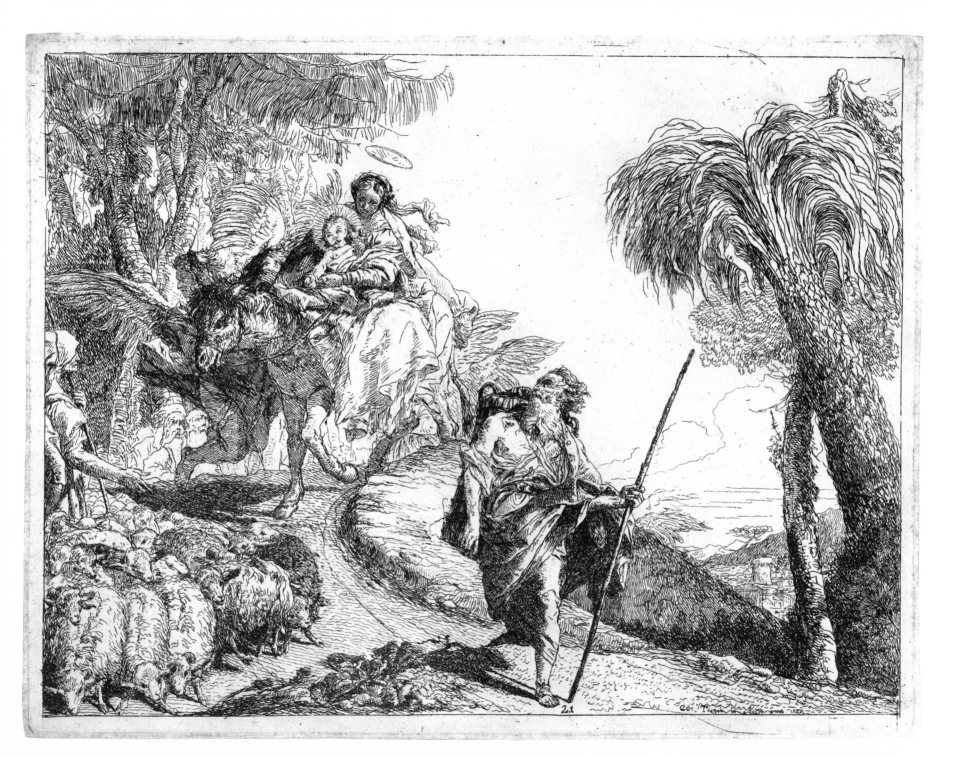

2.1

PLATE 22

The Apocryphal New Testament records the legend of Christ's effect upon pagan idols:

> And now he drew near to a great city, in which there was an idol, to which the other idols and gods of Egypt brought their offerings and vows. . . . And at the same instant this idol fell down. . . .

Adopted by the Church, the episode was authorized for representation in carved and painted series of Christ's childhood. The pictorial tradition, some five hundred years old, must have impressed Tiepolo, who made his illustration of Christ as an iconoclast the most formal and conventional composition in this set.

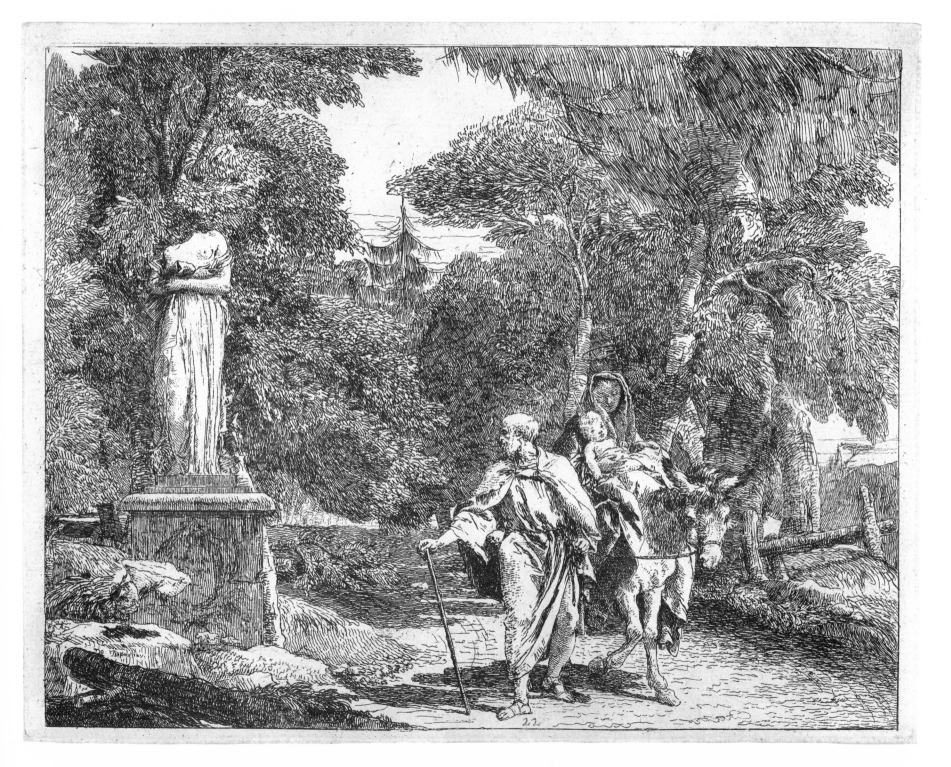

22

PLATE 23

On one occasion a fountain miraculously sprang up at the infant's command. Called the Fountain of Mary, it is said to exist still northeast of Cairo. The spring appears frequently in Italian paintings of the Repose.

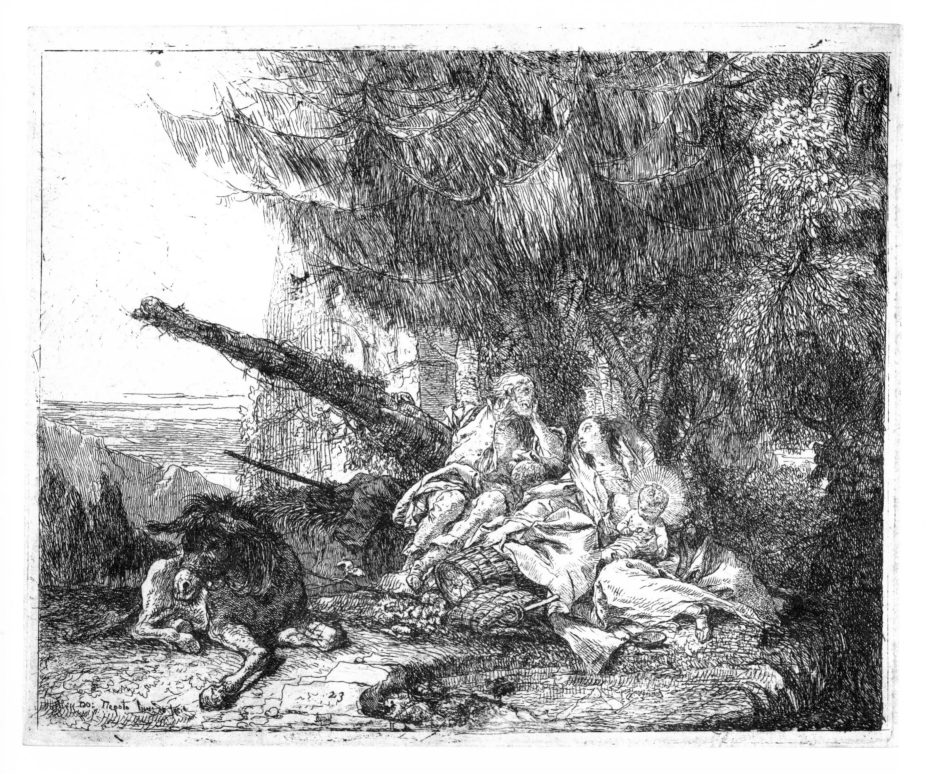

PLATE 24

This plate and the two following show how Tiepolo approached his etchings as exercises in composition. In these scenes he begins with the same constricted, stage-like space and pyramidal hillock, then maneuvers his figures into various positions and changes the tree from palm to pine to fir. The trees, shepherd, and quizzical sheep are adapted from Castiglione's version of the Flight, etched a century earlier.

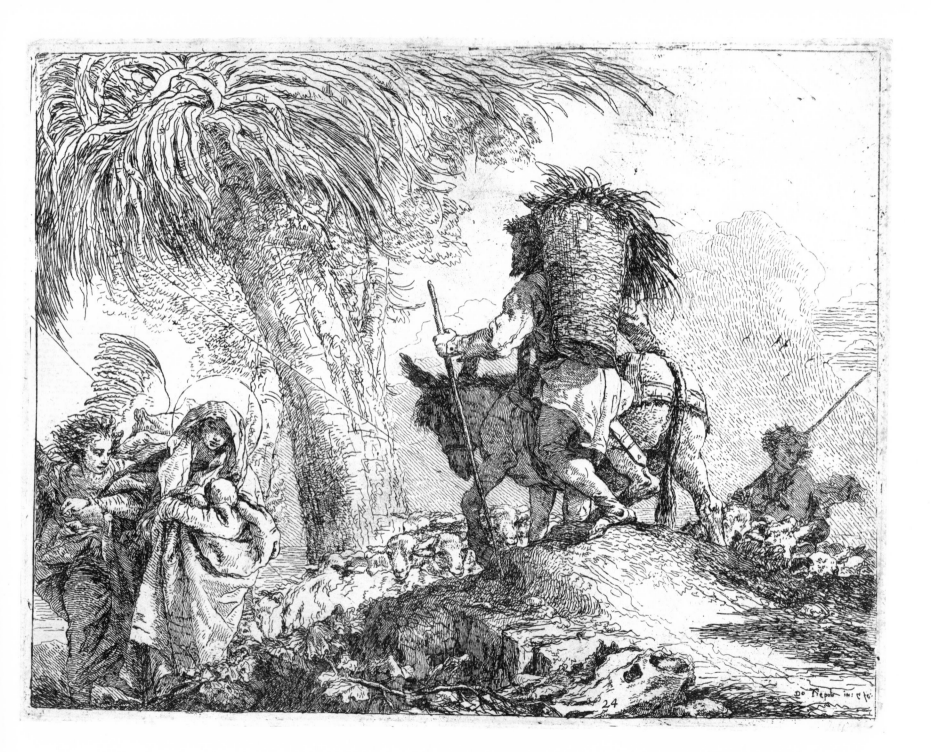

24

PLATE 25

Tiepolo's repeated use of the hillock gives a halting rhythm to the final phase of the journey. The travelers' grave expressions and weary pace confirm these last steps as the most difficult.

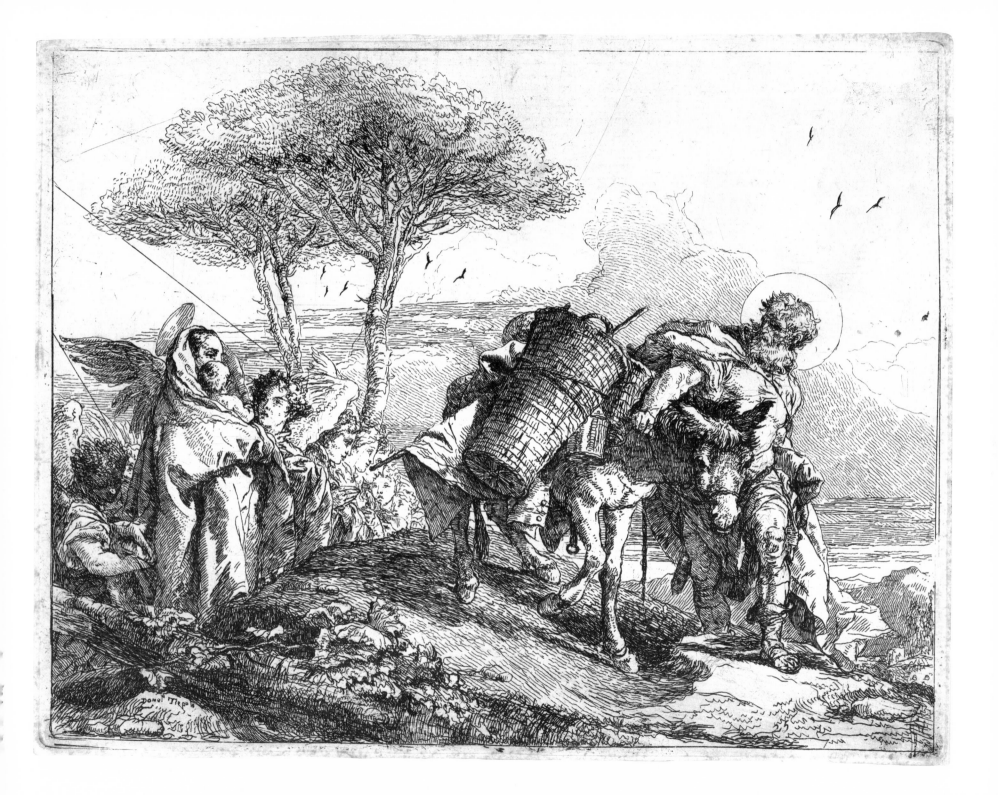

Domo Tiepolo

PLATE 26

Joseph looks back from the summit for assurance that Mary and the child are close behind. On this last climb Mary spares the weary animal the burden of her weight; she proceeds on foot, supported by angels. This is Mary in the role of Mater Dolorosa, as she will be comforted in scenes of the Passion, the Crucifixion, and the Entombment.

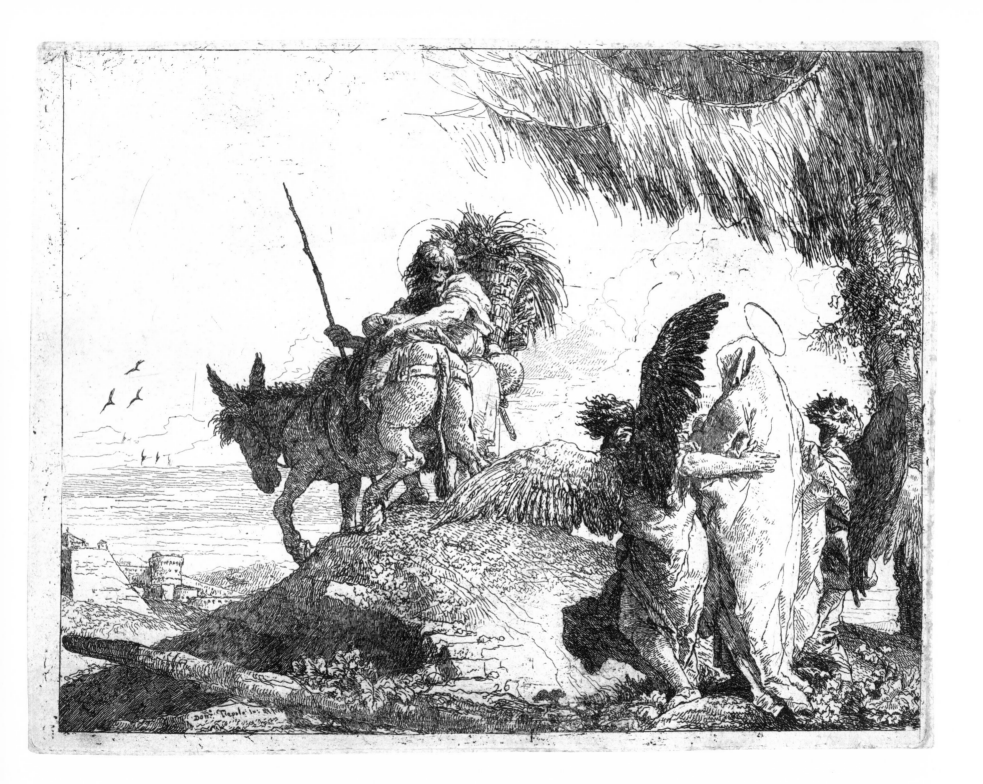

PLATE 27

The gates of the Egyptian sanctuary are reached at last, but no one greets the Holy Family. Instead we see, ignorantly thronging ahead, the same sort of mixed assembly that witnessed the departure from Bethlehem. Since it would be a sacrilege for the backs of so many to be turned against the Virgin and her son, Tiepolo has Mary turn away to gaze back in contemplation of the long journey that has now come to an end.

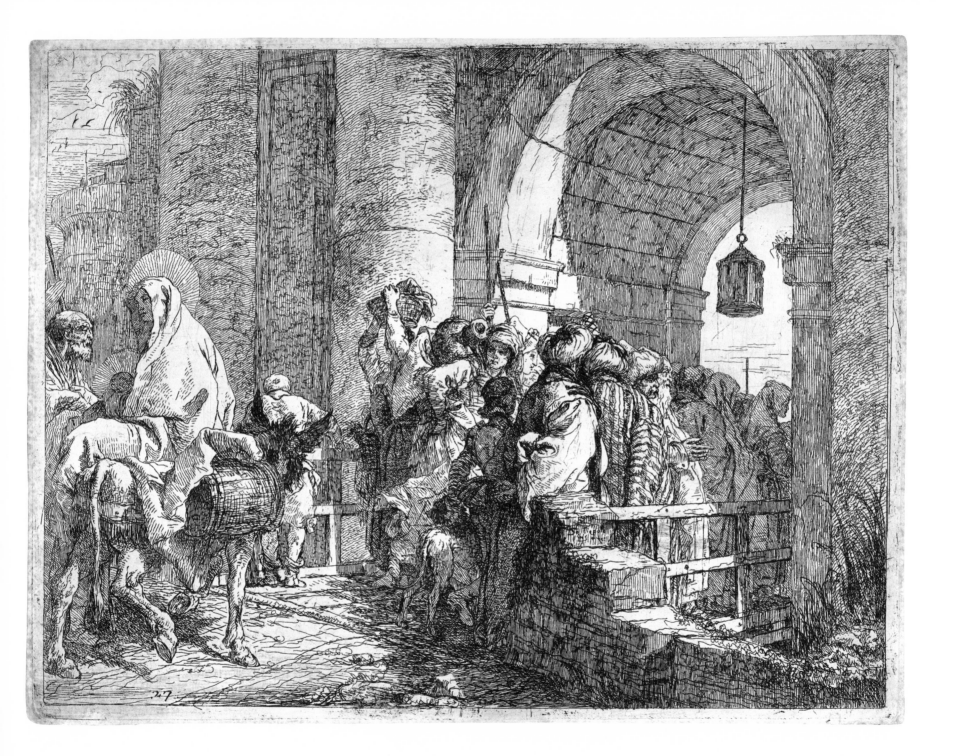

THE FLIGHT INTO EGYPT *was designed by Carol Shloss at the Press of David R. Godine.*
It is set in Aldine Bembo roman, a recutting of a Venetian typeface that originated with
Francesco Griffo in the late 15th century. The text was set in Monotype at
the Press of A. Colish, printed by The Meriden Gravure Company on
Mohawk Superfine paper, and bound by A. Horowitz & Son.
The cover paper was reproduced from the paper sides
of the booklet, The Triumph of Virtue,
by Guiseppe Albertinelli, printed
in Venice in 1767.